Best Coloring Book: State Series Maine Coloring Book

Created by

Jason Best

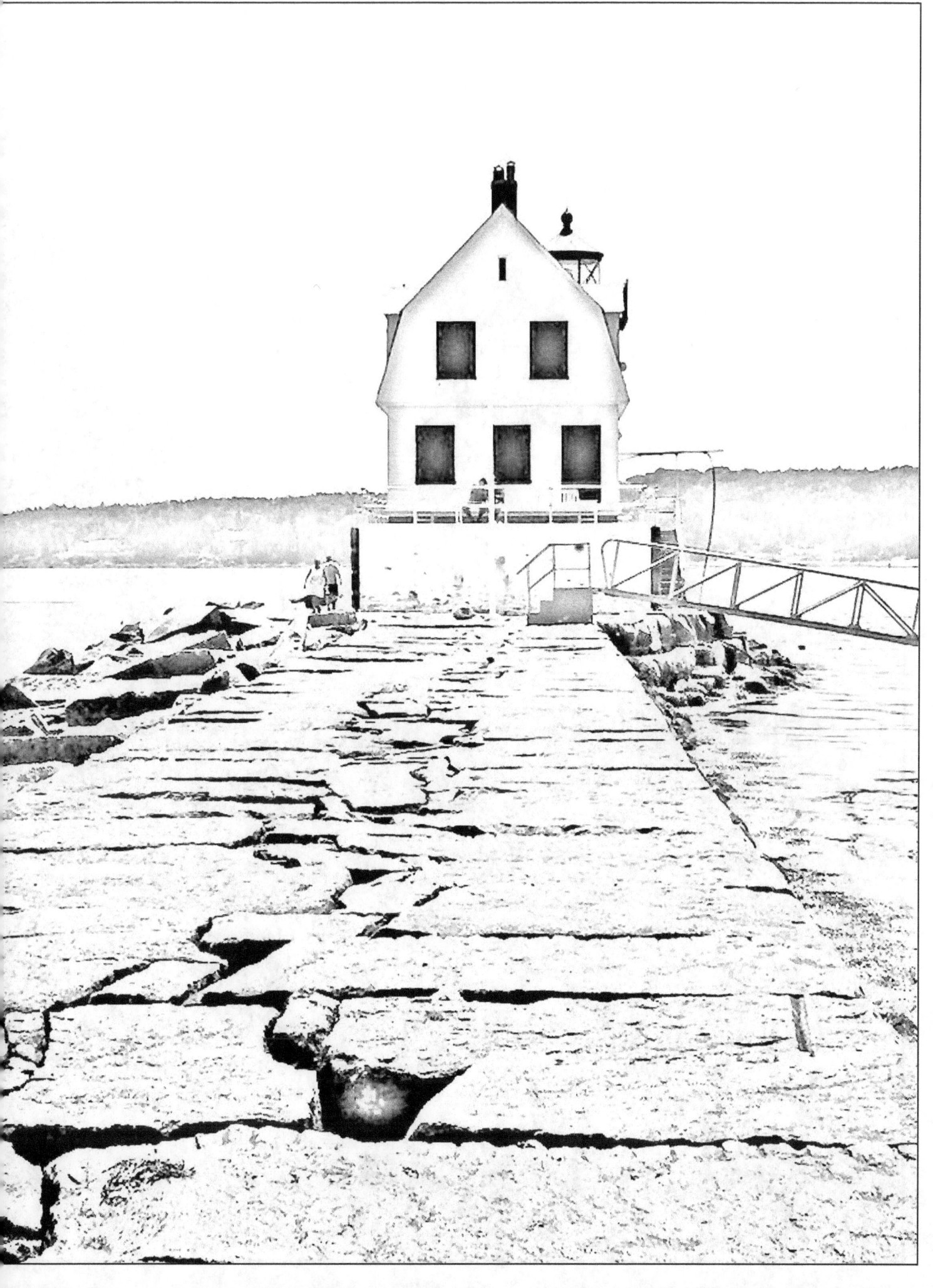

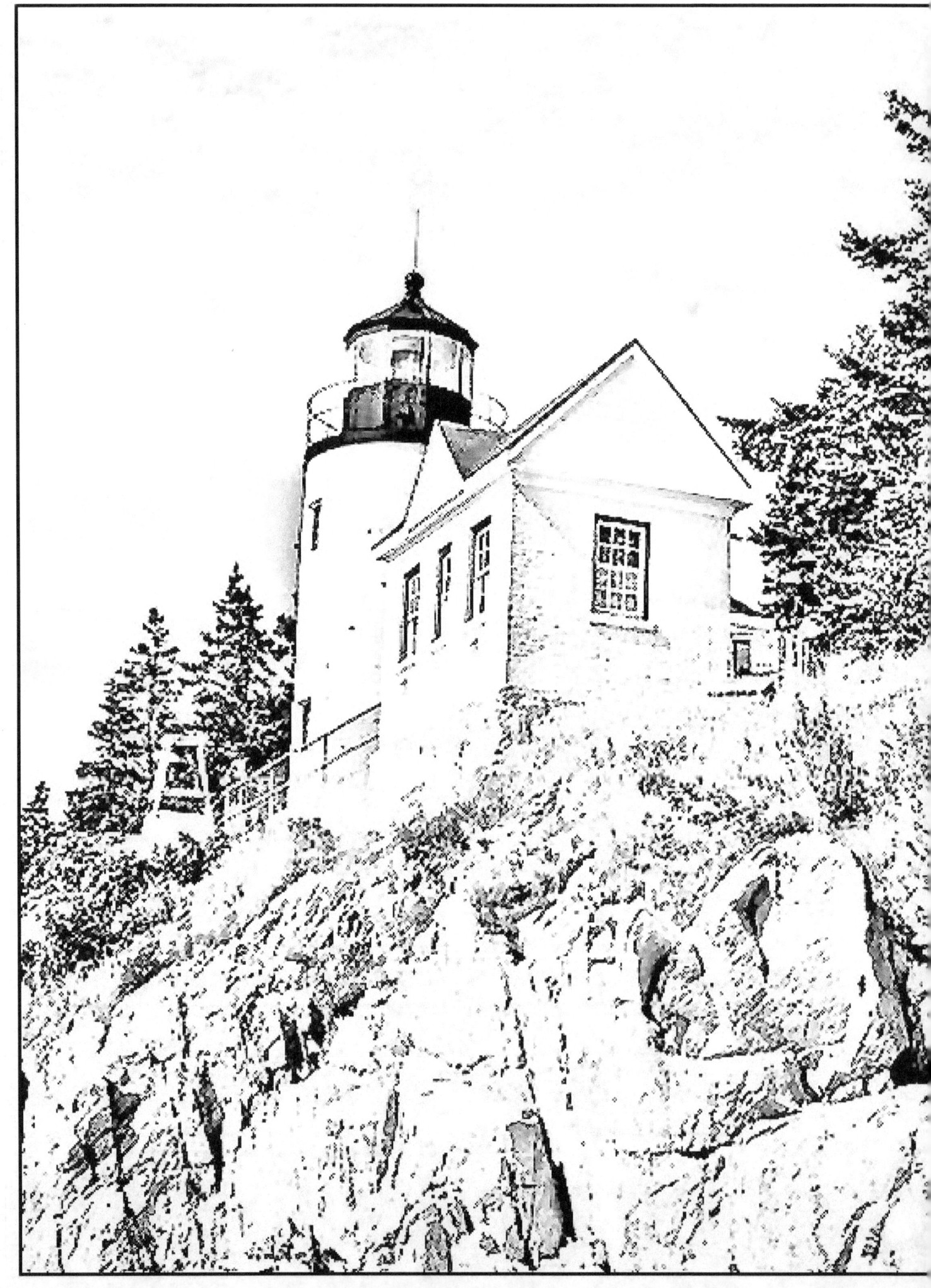

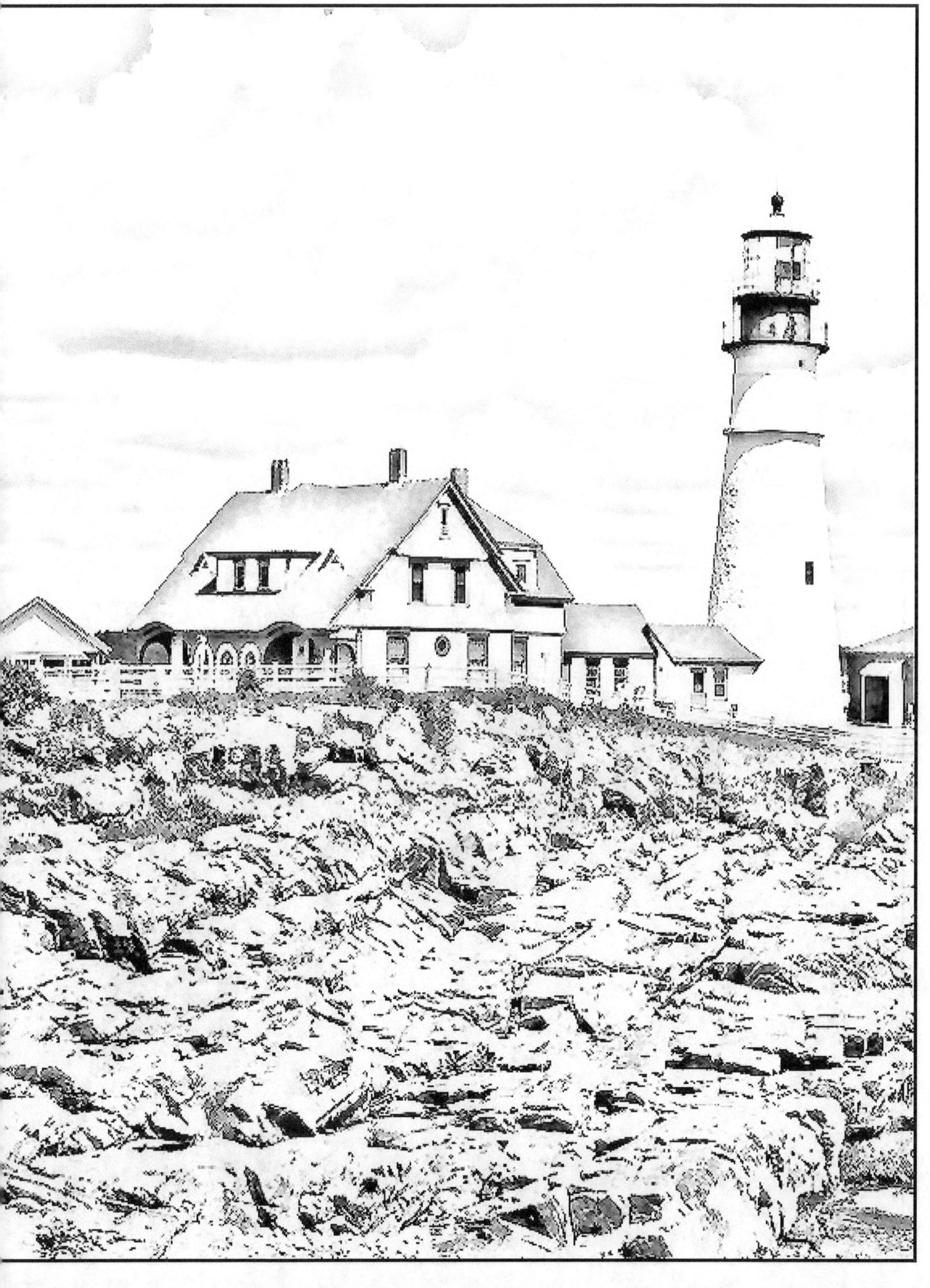

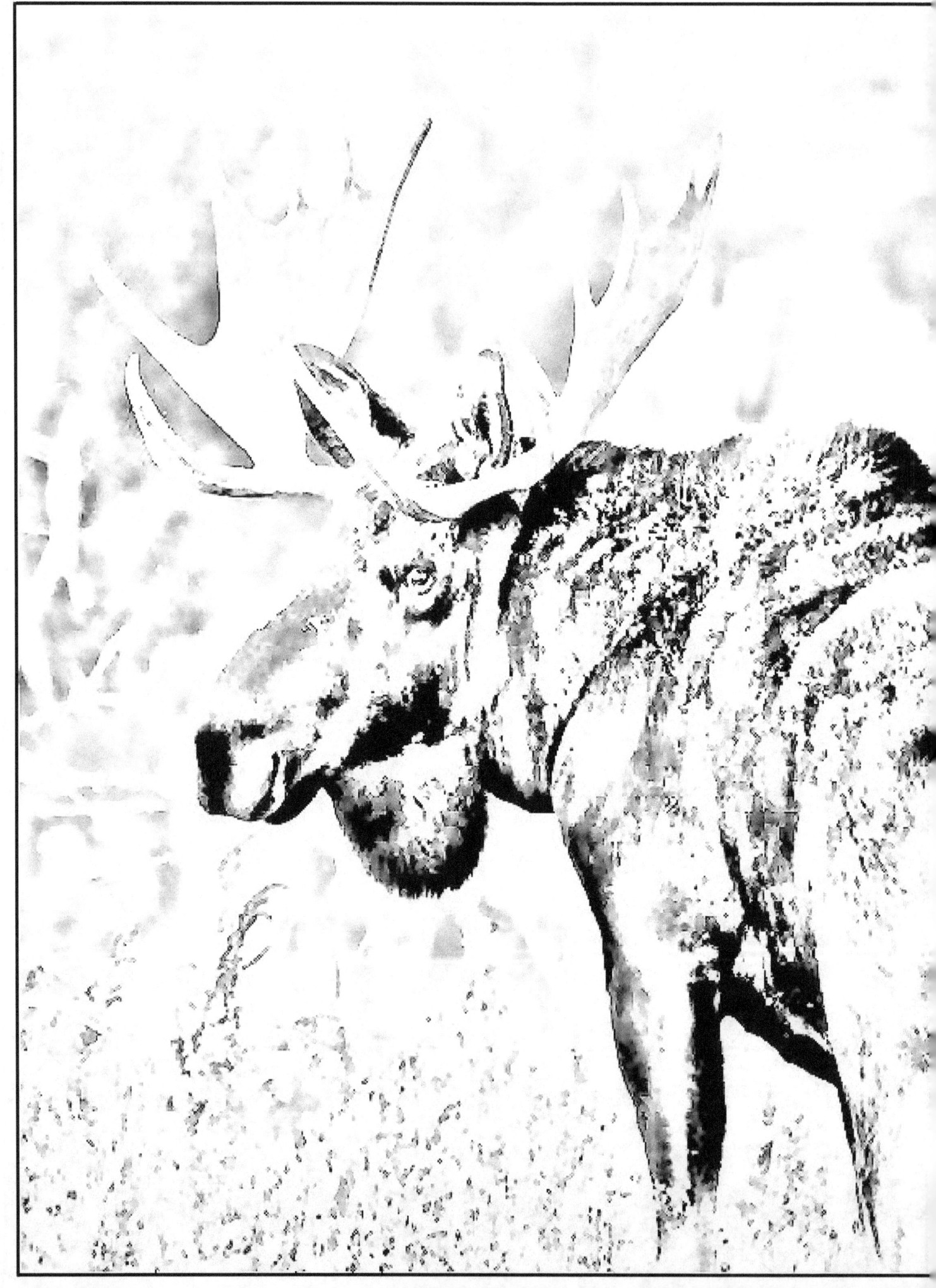

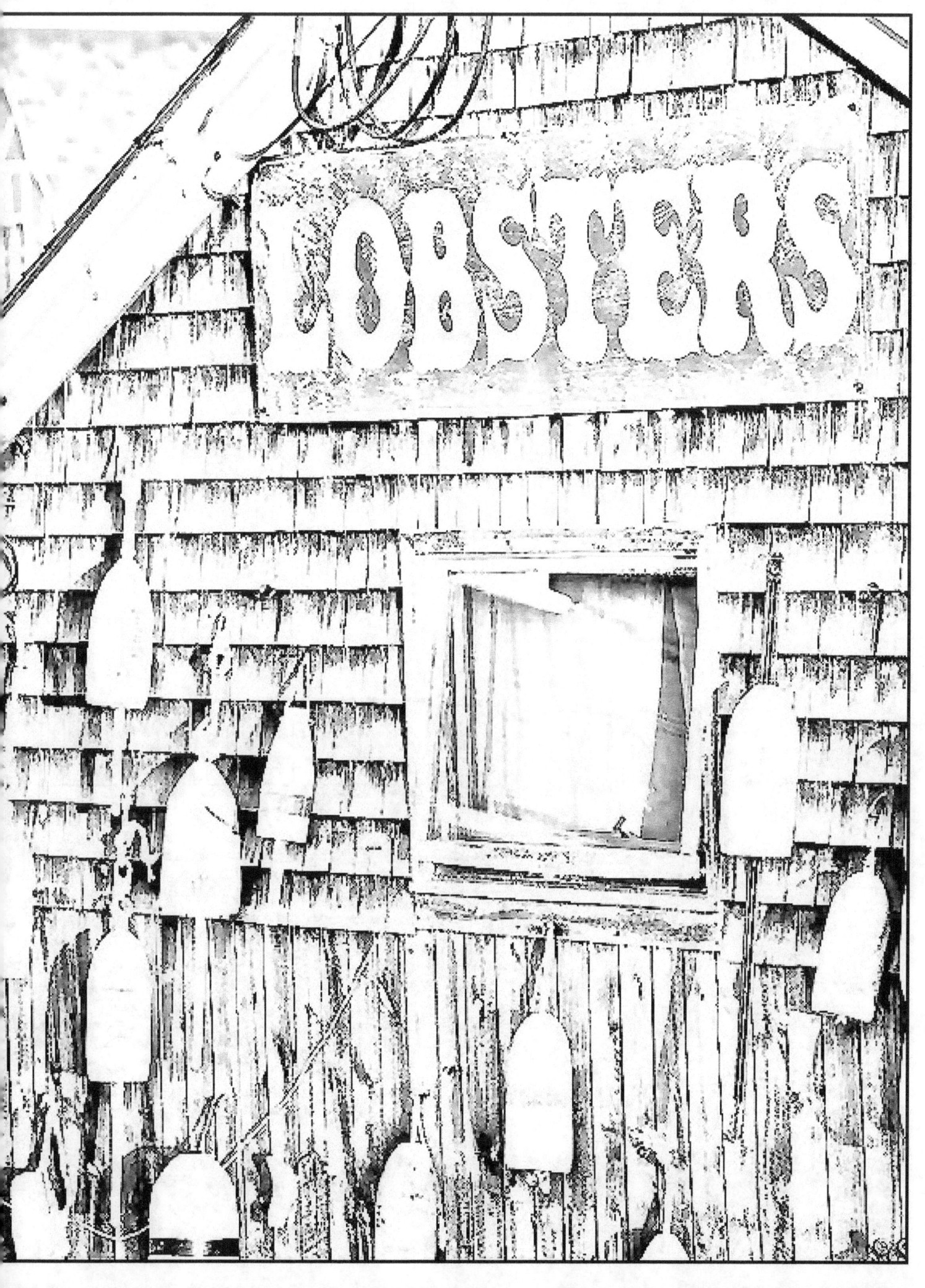

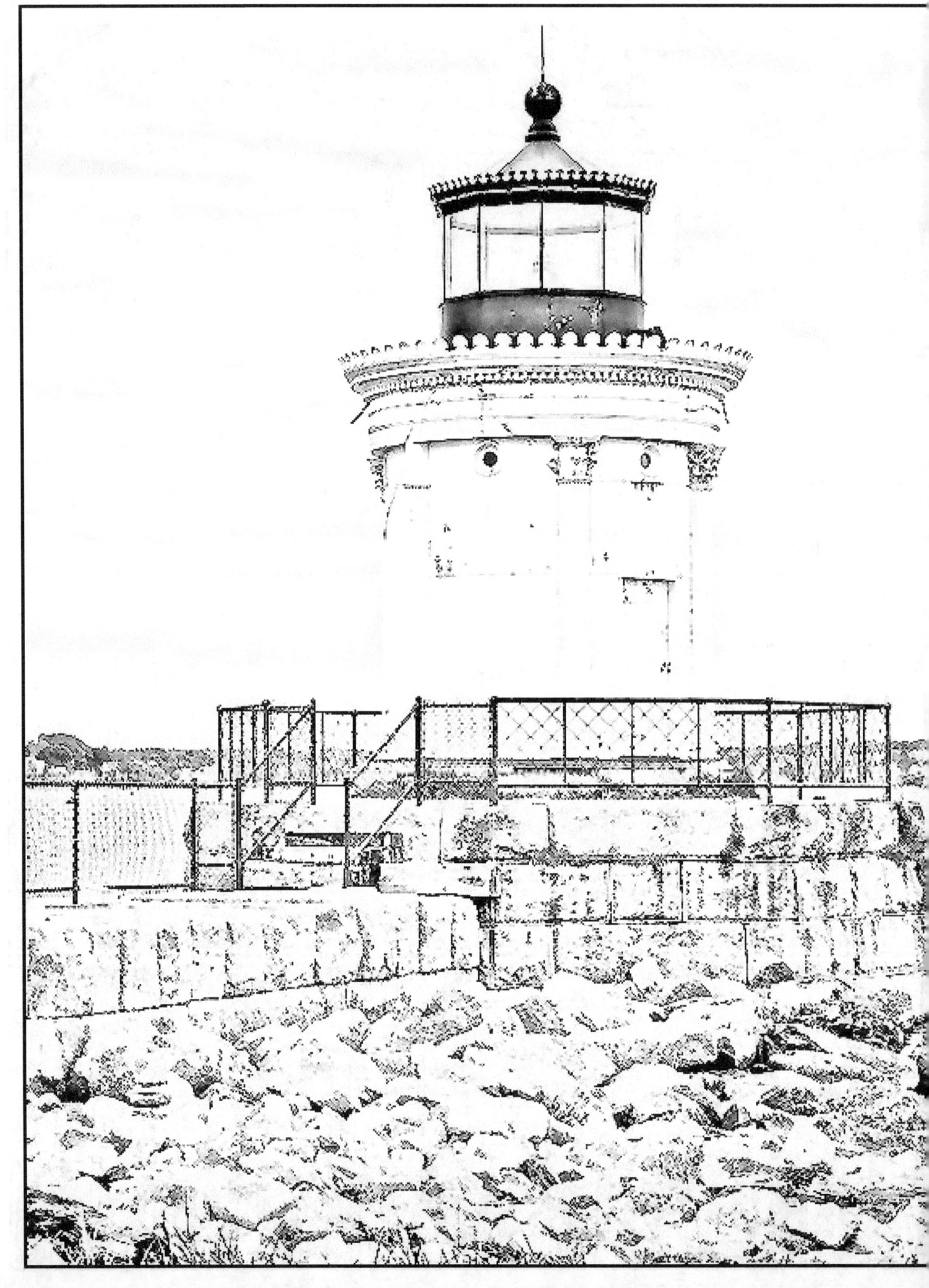

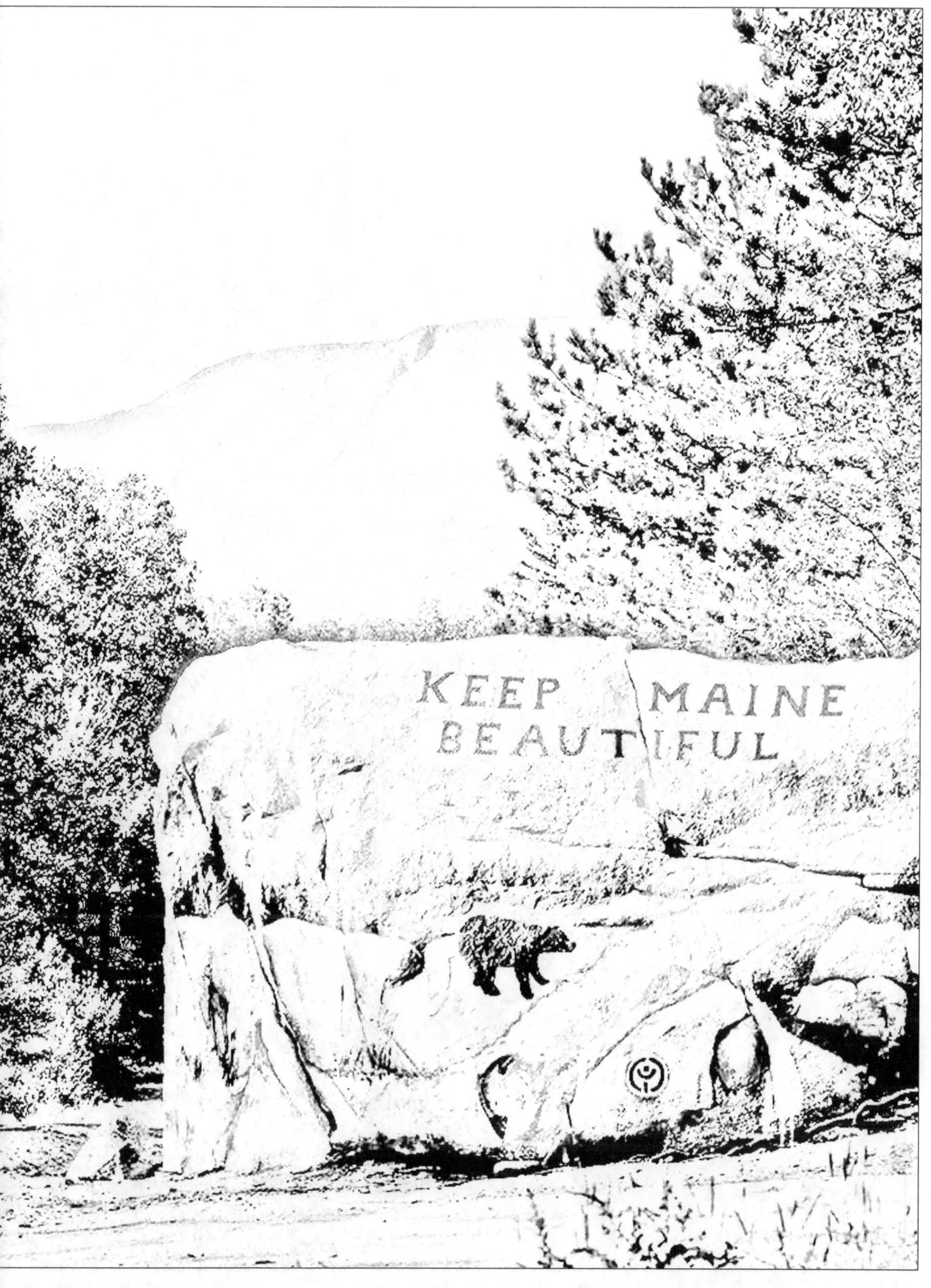

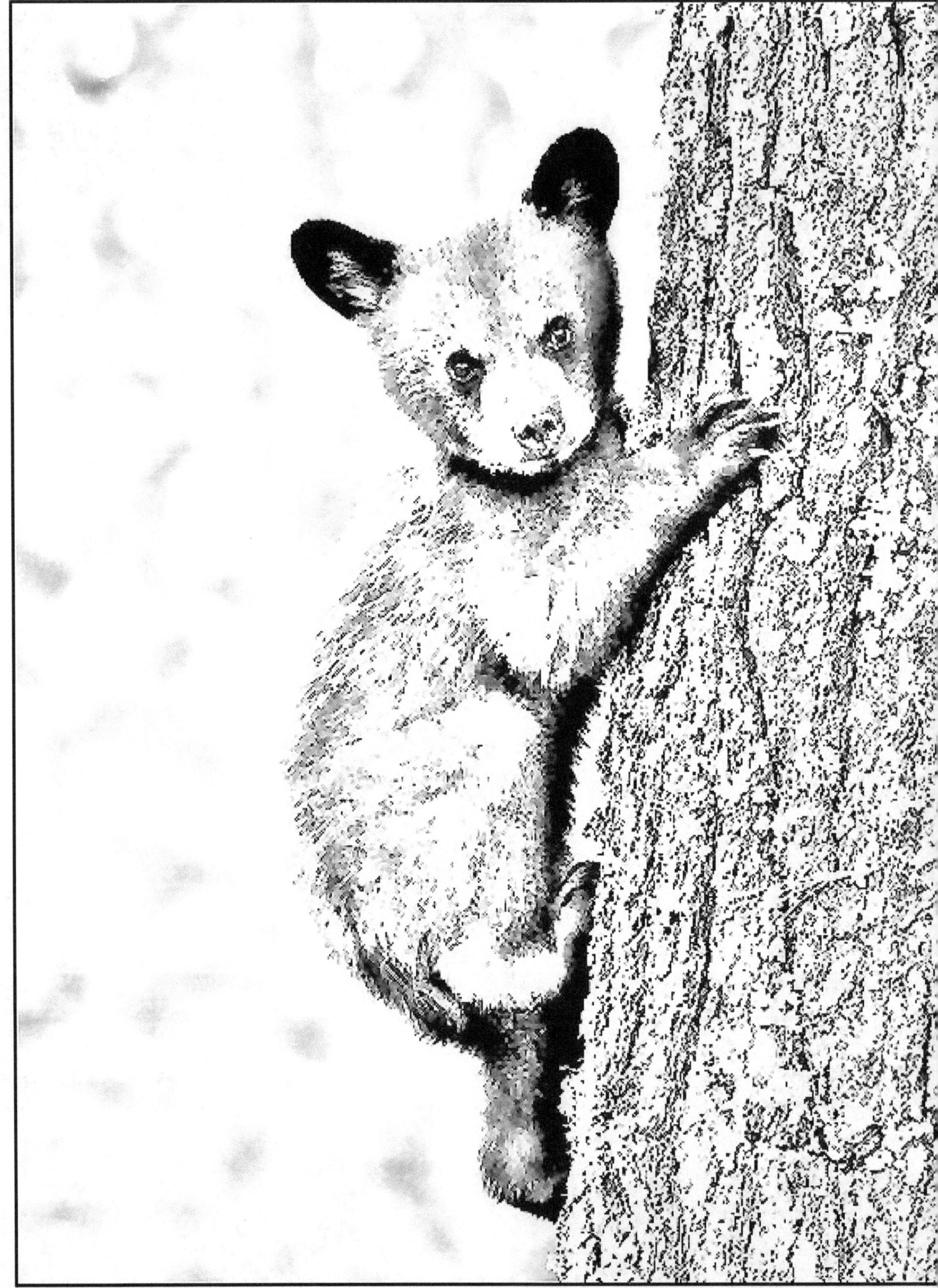

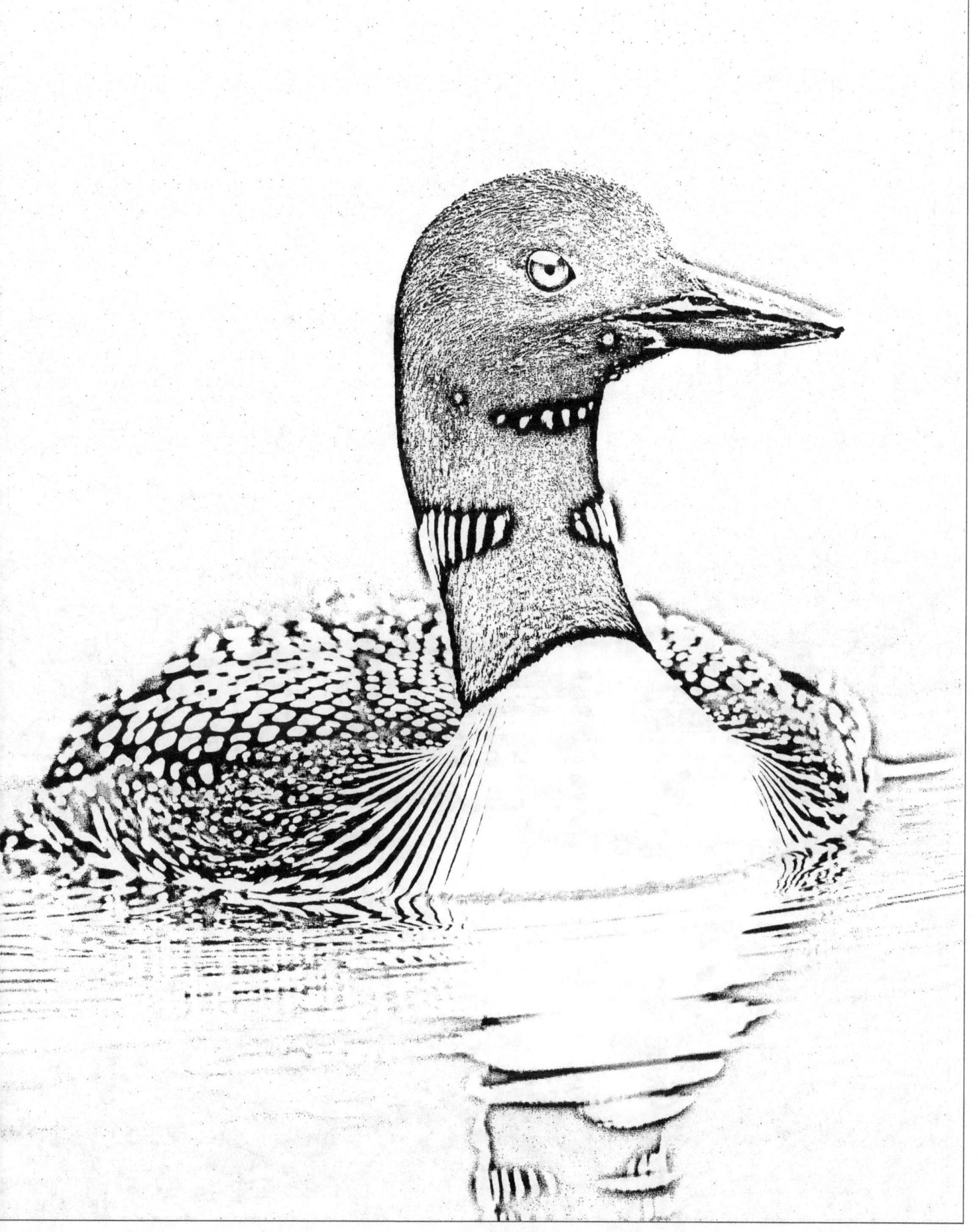

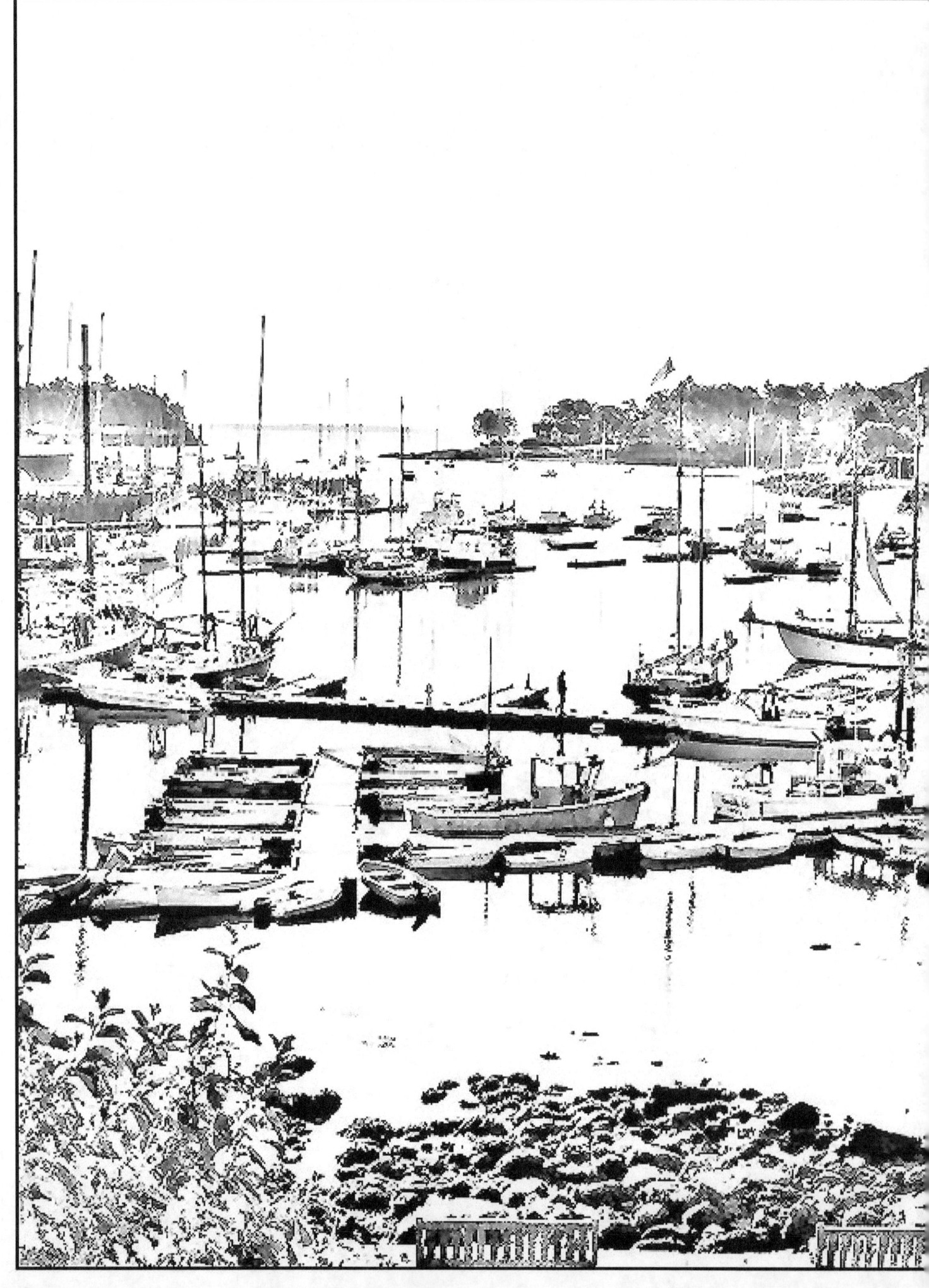

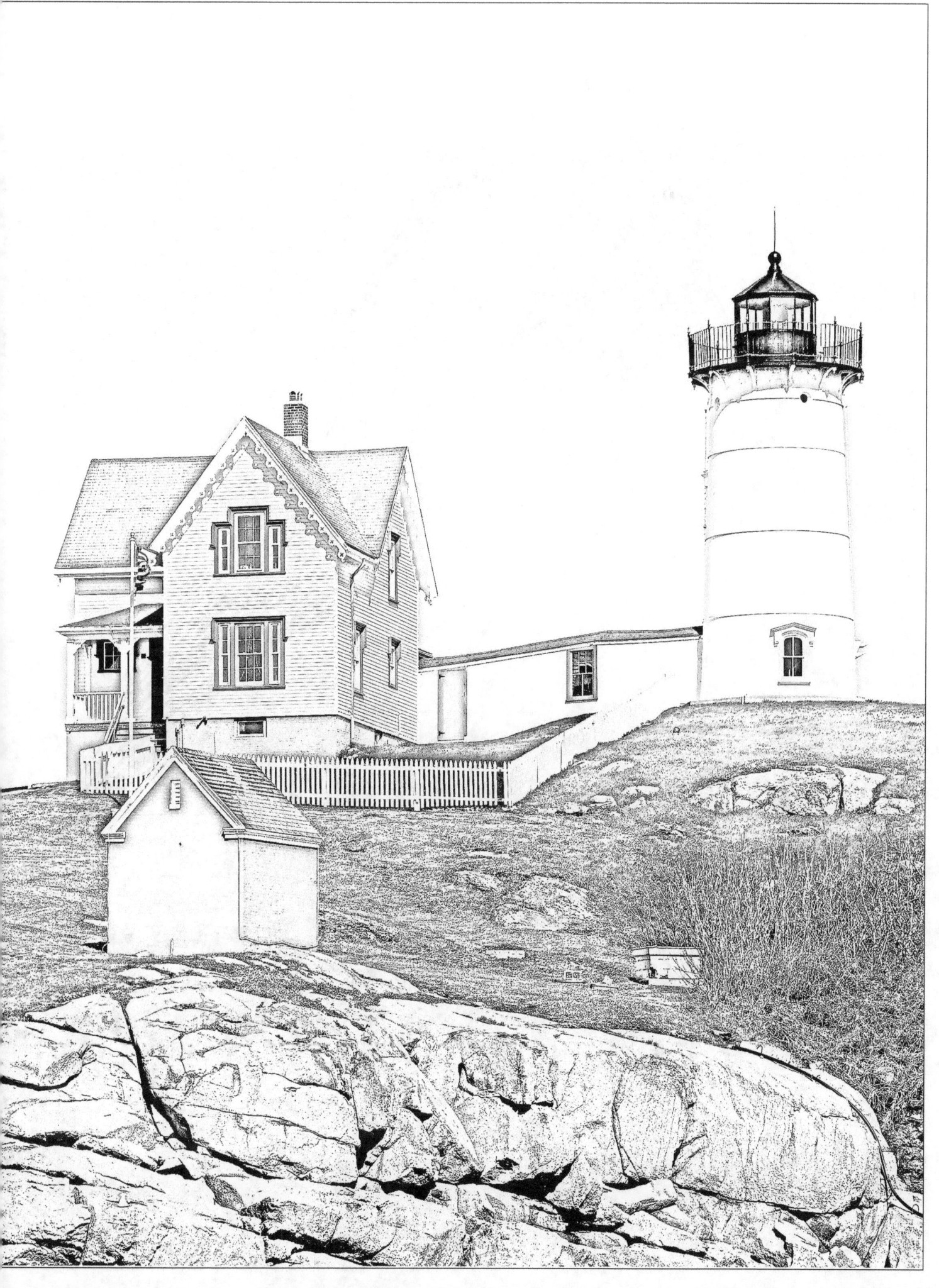

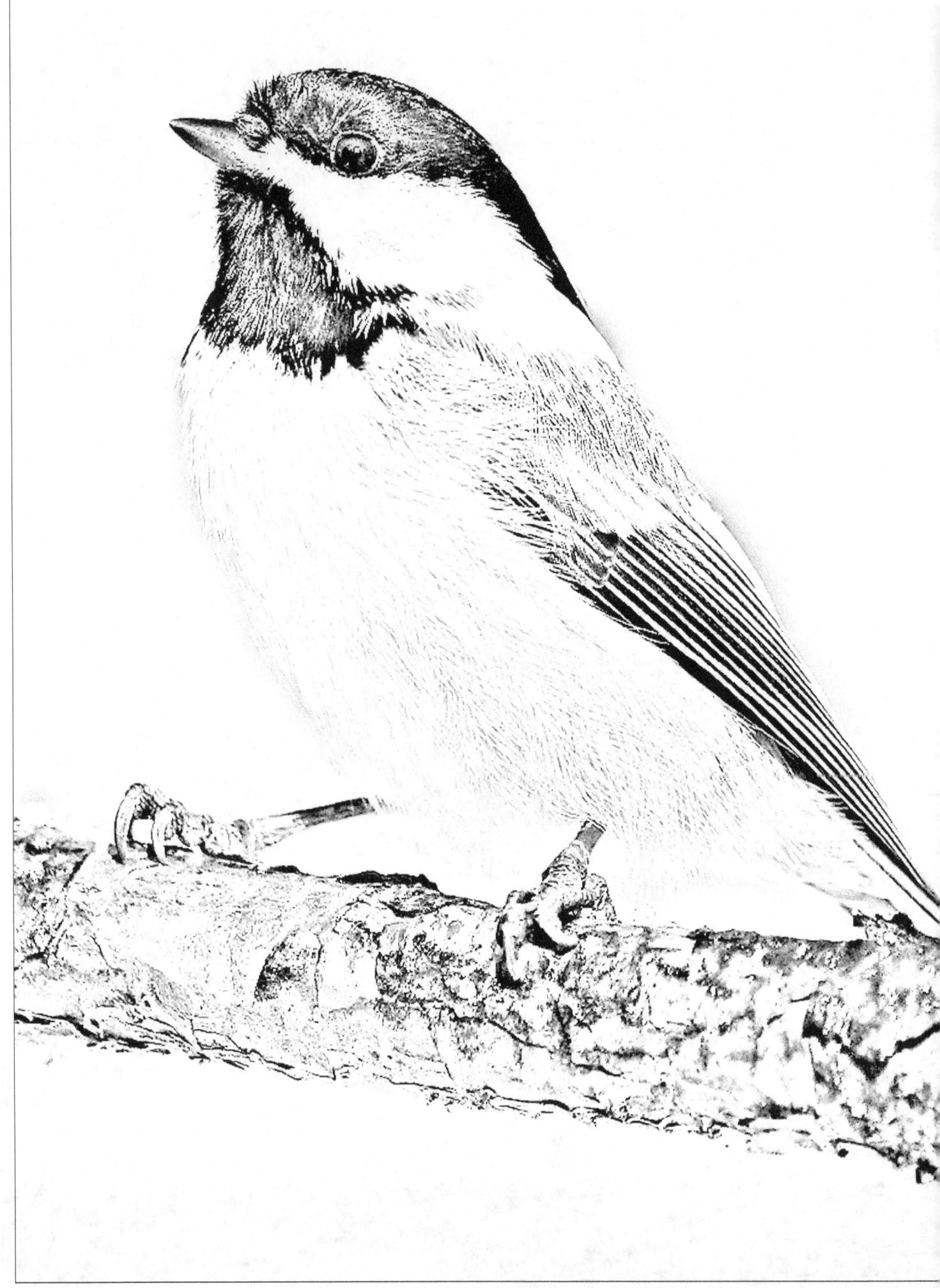

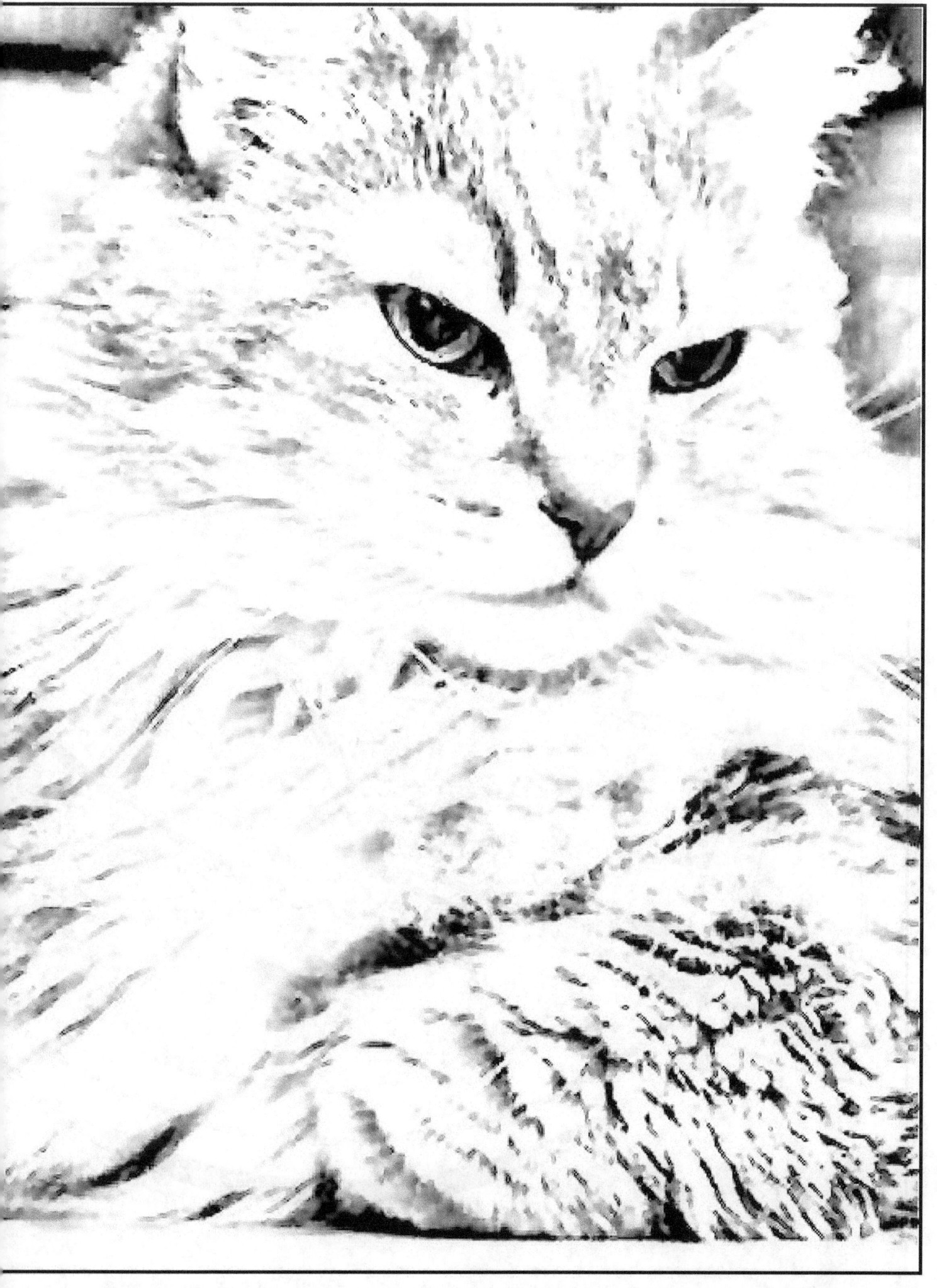

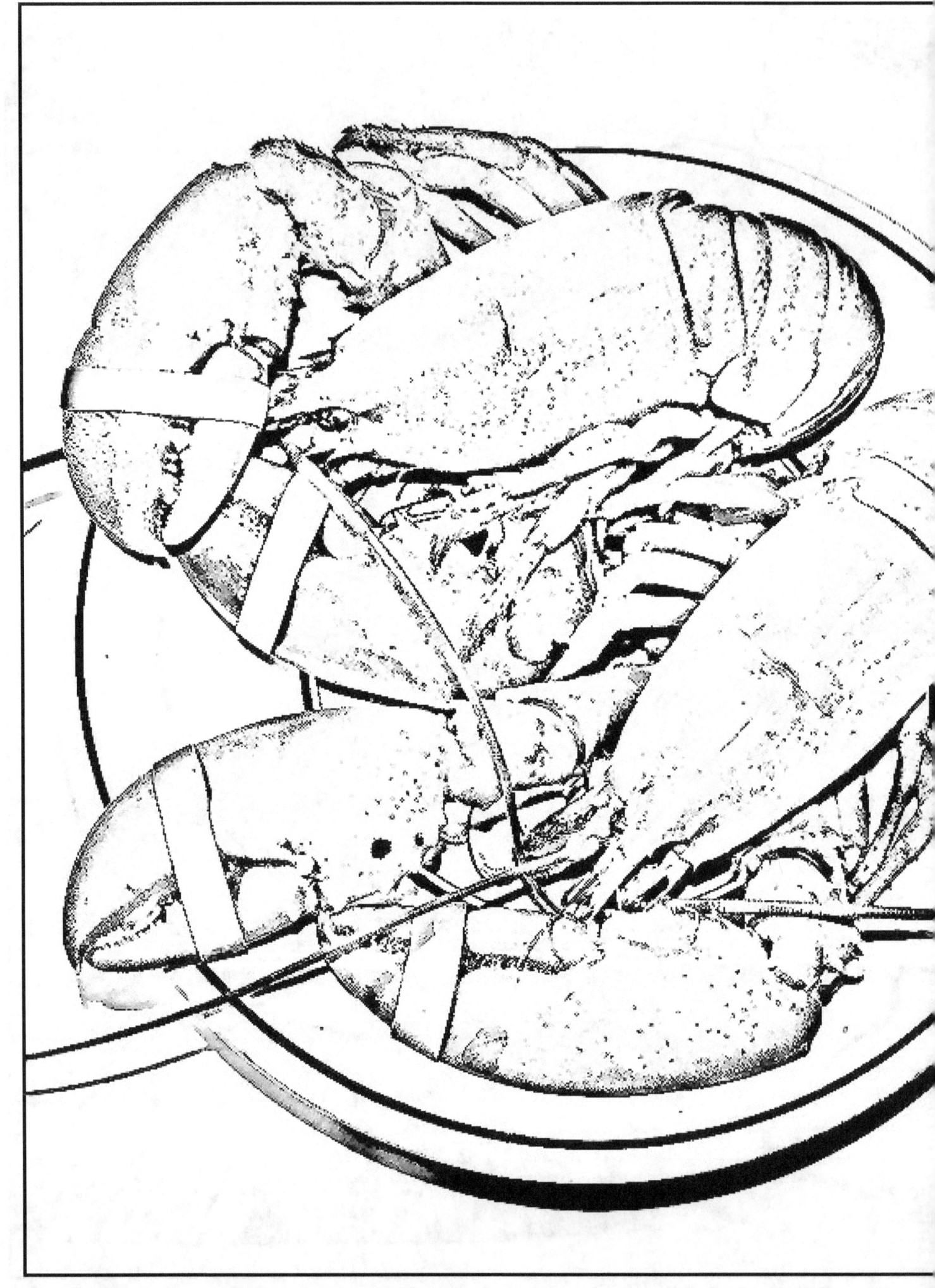

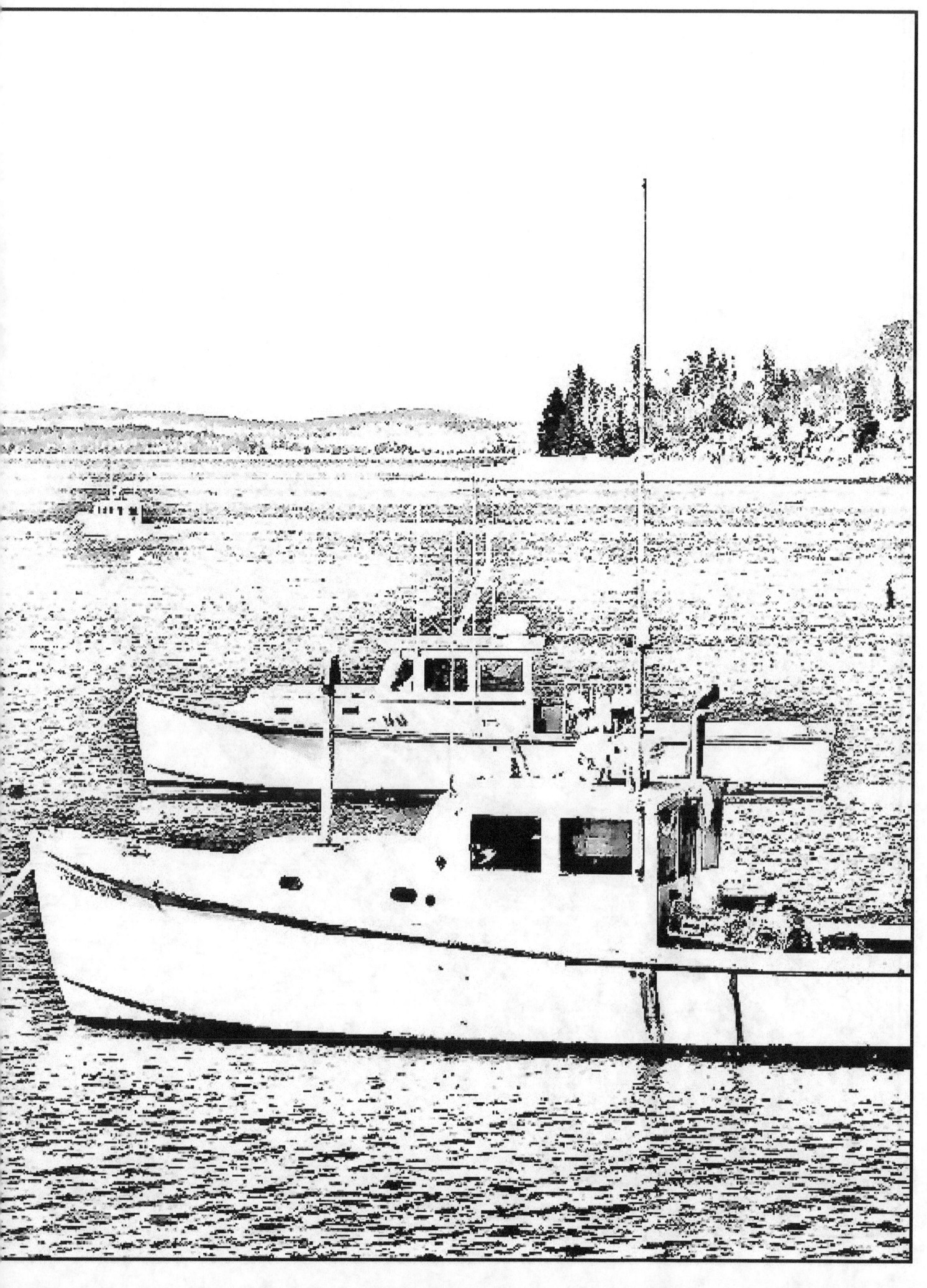

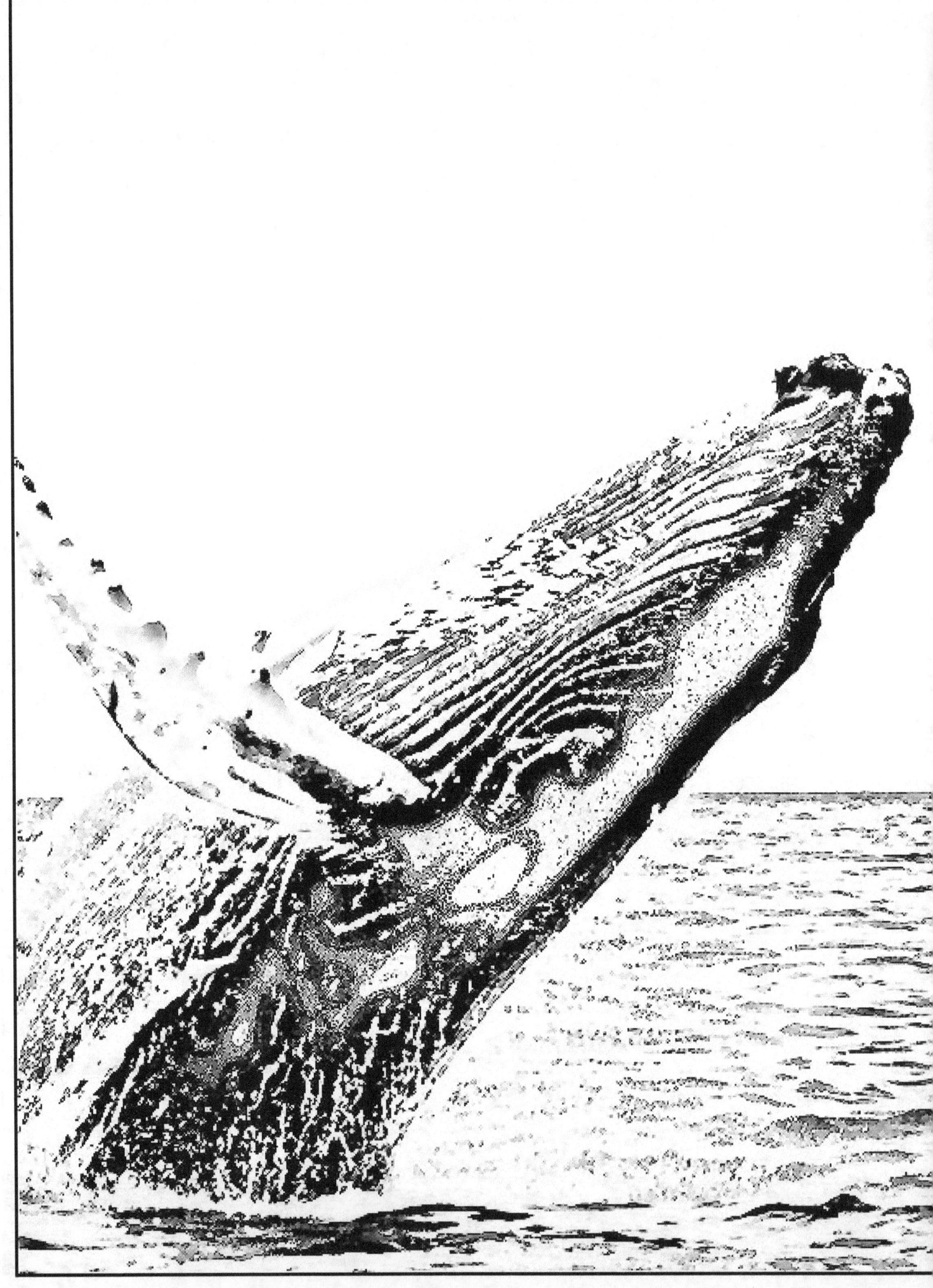

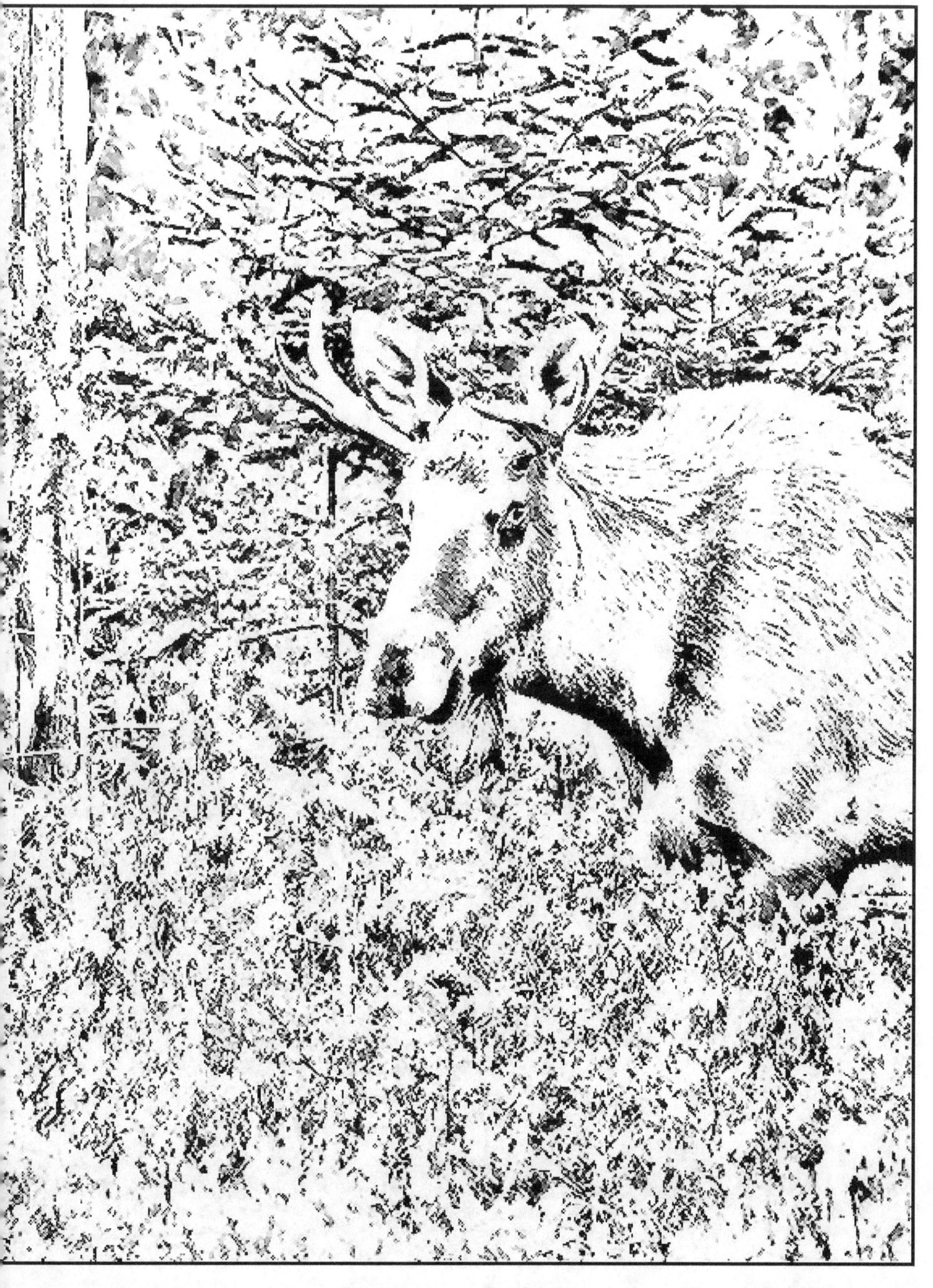

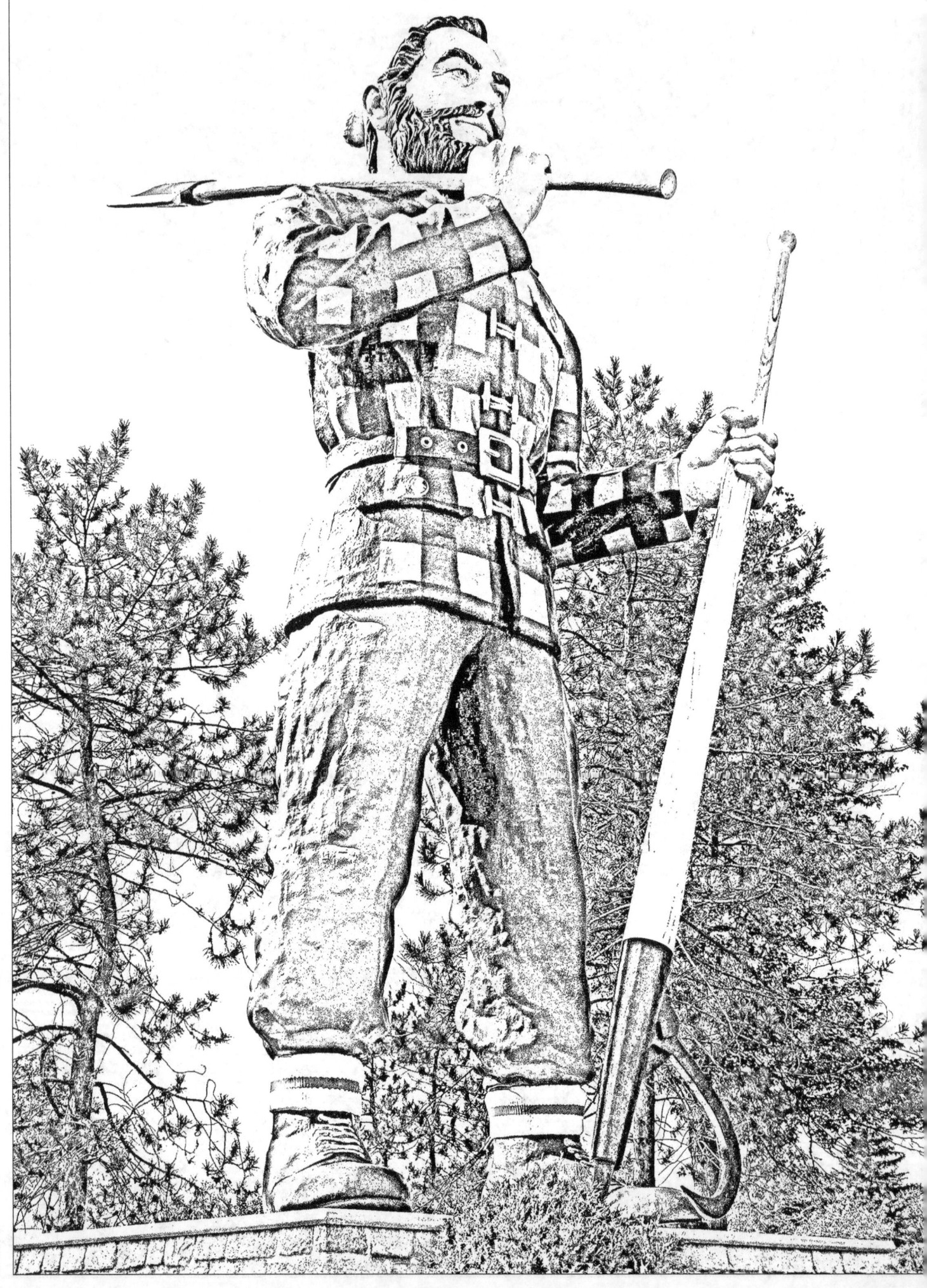

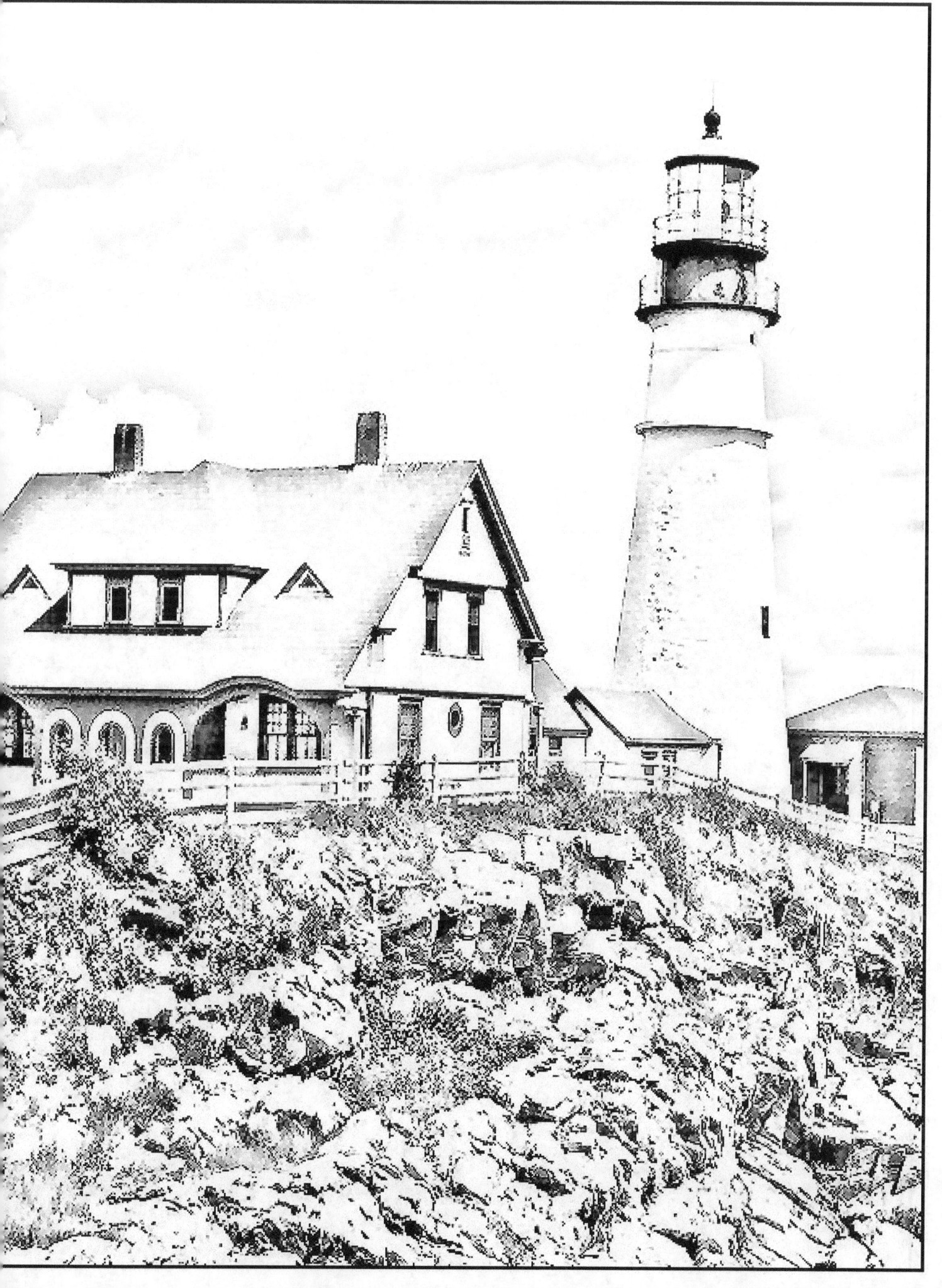

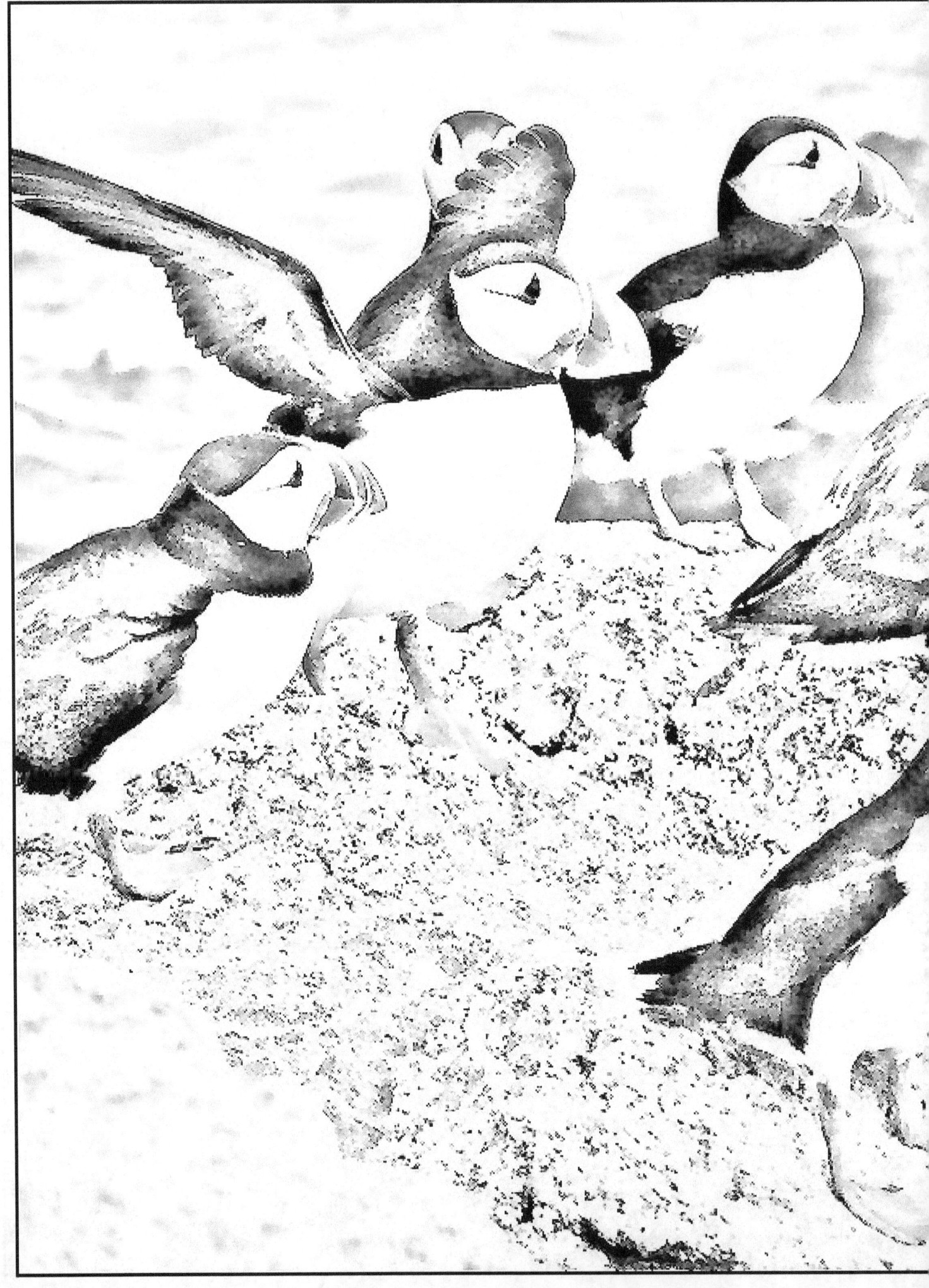

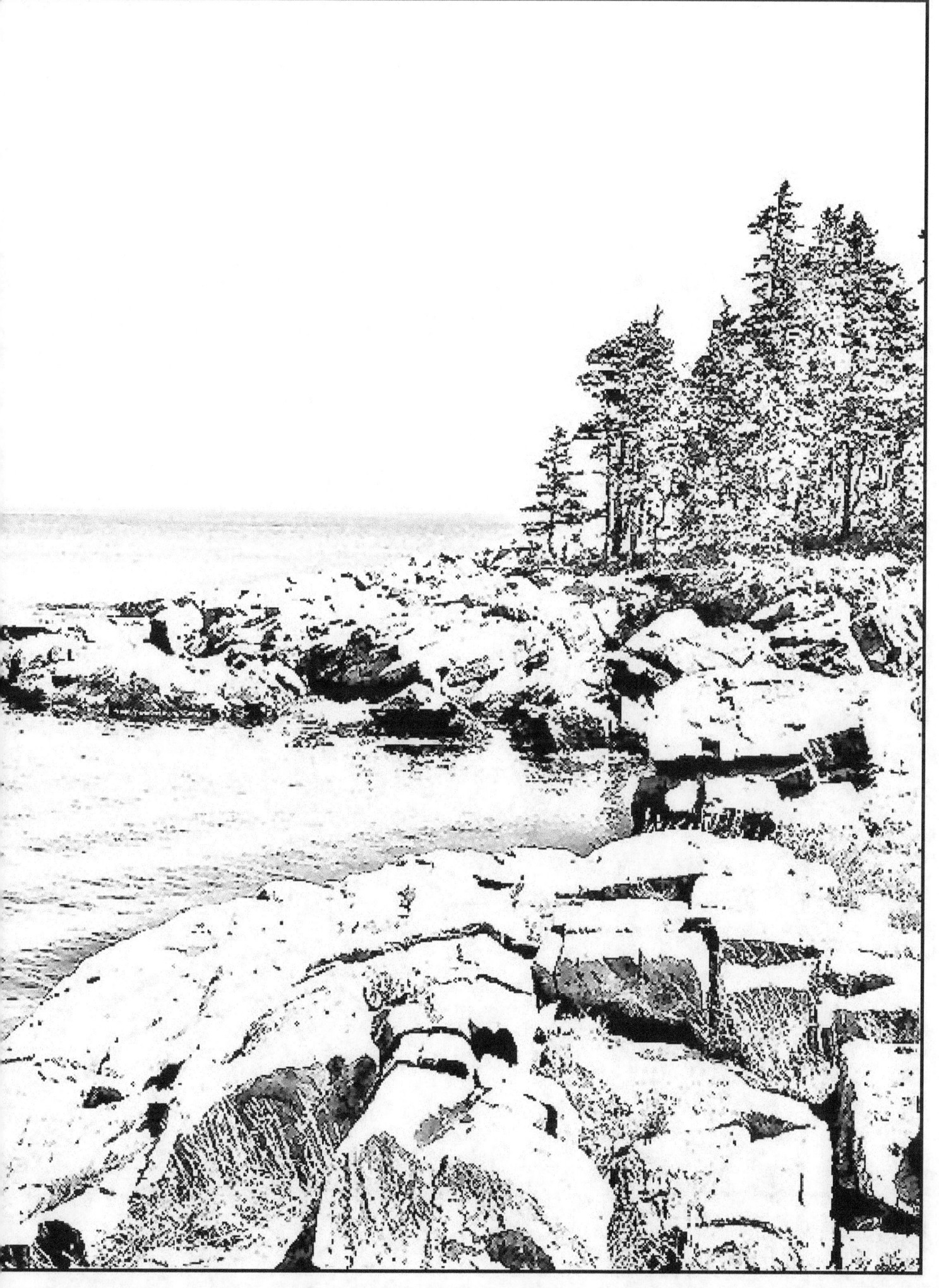